Also by Cynthia Rowley and Ilene Rosenzweig

Home Swell Home: Designing Your Dream Pad

Swell: A Girl's Guide to the Good Life

Coming soon:

The Swell Dressed Party

Swell Holiday

TURNING UP THE TWINKLE

Cynthia Rowley and Ilene Rosenzweig

ATRIA BOOKS

New York　London　Toronto　Sydney　Singapore

ATRIA BOOKS
1230 Avenue of the Americas
New York, NY 10020

ISBN: 0-7434-8214-X

First Atria Books hardcover edition October 2003

Art direction by Julian Peploe
Photos by Lee Clower

10 9 8 7 6 5 4 3 2

For information regarding special discounts for bulk purchases,
please contact Simon & Schuster Special Sales at 1-800-456-6798
or business@simonandschuster.com

Manufactured in the United States of America

For Kit Clementine and all the other swell girls
who still believe in Santa Claus.

Peek inside . . .

Swell Holiday

Stockings Full of Miracles

This is the time of year when a Swell girl really turns on the *twinkle*. Flirting at office parties, making spirits bright, having sexy punch-bowl moments, jingling all the way, speed-shopping for toys, dashing through the snow, skating on thin ice, baking, burning, wrapping and tipping and shipping and forgetting and spazzing out like a freak racing around the house with a turkey baster!

Ho-ho-hold on there. 'Tis the season to be jolly. It's too easy to let the festivities spiral into a blizzard of stresstivities. *Where the heck are my elves?* This is a season when the buzzwords are JOY and HAPPY and MERRY. It is possible to

snowplow through the lists with rein-
deer swiftness and maintain mental
peace on earth; to make things seem
homespun and keep your sparkle. For
that, however, you'll need some holiday
magic! Like knowing how to come up
with "thoughtful" last-minute gifts, or
pomp up a pair of plain pumps for the
office party. Open up the holiday deco-
rating spectrum—from red-and-green
to an all-white Winter Wonderland.
And maybe a few easy noncheesy craft
ideas that don't end up with you in a
tangle of pine needles and chicken wire,
explaining how it was supposed to be a
"swag" for the mantel.

To get into the Swell holiday spirit, follow our Three Wise Moves: Tweak the traditions. Work your own miracles. Put some thought into it, but don't overthink.

Hang Mom's popcorn balls from your own pink Christmas tree. Invent "olive-branch martinis" to wash down the latkes for your annual Hanukah fest. Whatever it takes to keep from wrapping yourself too tight. Run out of ribbon? Tie the scraps end to end, creating a "kite ribbon." It'll fly if you remind yourself that on the holidays everything looks better when it looks homemade.

The eight chapters in this book

show how to preserve the kidlike fun, wonderment and mystery of the holidays—midnight sledding party! —and keep the season from getting too commercial. After all, it's the end of the year, and a Swell's gotta try for that *It's a Wonderful Life* happy ending. Why wait for an angel to come to the rescue? String Happy Lights on the wall, and remember that a Swell girl is an unrepentant holiday tart. She celebrates everything she can think of—it really doesn't matter what. It's all just an occasion to make mirth, spread merriment, show good will toward men—and wear Santa's parka with nothing underneath.

Chapter 1

Gifts

A Partridge
in a Pear Tree?

THE MOST MEMORABLE GIFTS ARE
OFTEN THE LEAST PRACTICAL

'Tis better to give than to receive—except when you spend most of November and December spinning out of control in department stores because you have to get gifts for your brother-in-law's second cousins. The trick is to have as much fun dreaming up, collecting, and wrapping prezzies as the getters have ripping 'em open.

But how?

By mixing up the store-bought and the homemade, extravagant indulgences and little mementos, gifts planned months in advance and last-minute miracles. By throwing in a few surprises: something to get a laugh, or a token sappy enough it should be wrapped with a box of Kleenex. Just so long as it doesn't feel *generic*. Add something personal—even to a gift certificate. There are many ways to make a gift memorable without splurges of time or money.

Just please don't be too practical! Did the Three Wise Men bring Mary and Joseph a stroller?

HOMEMADE GIFTS

If You Don't Like it, You Can't Return It

Far be it for us to diss the great American consumer spirit. But there can come a soul-deadening moment when you look at all the sweater boxes and pine for a holiday that feels—how should we say?—a little less *commercial*. Put some Laura Ingalls Wilder back into the gift giving. Imagine your cabin is miles from any mall or general store, weeks from the next Pony Express delivery, but you want to come up with something great for Ma and Pa. . . . Going old-school doesn't have to mean making lace tussie-mussies, nutshell dainties, and other dust-collectors for the whatnot that require the kind of time and sewing skills you only have when you spend long winters in a cabin on the prairie.

A Swell can fill her stockings with quick and quirky homemade treasures without a glue gun or even any craft skills to speak of, because she is supercrafty.

Cover a Carol

Sign yourself up for your very own, very independent, record label, and record your *Top Ten Holiday Hits*. All you need is your trusty tape recorder and a holiday songbook. Press

Record-a-Carol. When you're ready to take your act big-time, find one of those recording booths where you can make your own CD or hit the big city and set up a recording session. Lots of studios will rent time to amateurs. Bring friends for backup. Stay up late struggling over the playlist to find the right balance of sentimental ballads, carols, and funk: an a cappella rendition of "Silent Night" that will make your mother cry; your harmonica solo of "Good King Wenceslas"; a cover of Adam Sandler's "Chanukah Song"; "Joy to the World," Three Dog Night's "Jeremiah was a bullfrog" version.

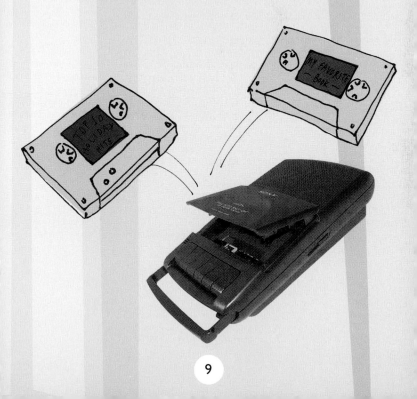

Holiday Song Book

If your voice makes dogs whimper, and your talents lie more in the mute hobby of fireside scrapbooking, scour the sheet-music store for your family's favorite holiday tunes. Slice them out and mount them in an album. Dress up the cover with a sentimental family photo, or just a title: "Joy to the World and other Cooper Family Classics." And a picture of a bullfrog.

Every-Occasion Stationery Collection

Keep an eye out for a pretty box. Could be fancy, a hand-painted Venetian wooden box from the antiques store, or a cool Lucite one from a tag sale. Even a candy box that seemed too good to throw away. Label the top "Sweet Note-things."

Make your box an "every-occasion secretary" by filling it with cards of all kinds. Pick them up in souvenir shops, museums, the botanical gardens—whenever one catches your eye. The more diverse the better. Elegant florals and arty postcards, vintage thank-you notes. Blank cards "monogrammed" with the giftee's initials on top, whipped out with a glitter pen and alphabet stencil. An envelope of stickers? Sure, that iridescent unicorn could go on a letter to your niece!

Book on Tape

Only you do the reading.

A spy thriller, a Penguin Classic, the *Guinness Book of World Records*. Make it through a whole novel and this present is as extravagant an expense of time as making a quilt! The only difference: You can't duplicate a quilt and give it to everyone on your list. Done! Book a spa day!

Work on your gift of words in the tub, in bed when you can't sleep. If a whole book is too much of a commitment, how about Cliffs Notes on tape, or a short story, a collection of poems, a compendium of priest and rabbi jokes. Particularly sweet for someone who—we're not naming names, *Nana*—is always complaining they never get to hear your voice. Add value by hamming it up with bad accents, maniacal laughter, deep sighs, maybe even footnotes.

Heirloom Recipe Box

Copy one of your family's heirloom recipes onto an index card and put it in an envelope. *That's it?* Well, you could . . .

Compile the whole family treasury on index cards in a regular recipe file box, alphabetized from Uncle Al's bread pudding to your sister-in-law Wendy's wings.

For the four-star version, write the recipe for Grandpa's

cheesecake on one side of the card and on the other side adhere a photo of the celebrity chef looking glamorous back in his svelte heyday. You might want to laminate, so as not to stain his fedora with strawberry topping.

Hollywood version: Earlier in the year, make a time when you and Aunt Sheila get together and videotape her making her famous babka. It'll be an archival keepsake if you can get her to talk about how she learned the recipe back in the old country. Keep the camera trained on her hands so you can see how much "just a handful" of flour really is.

Inspiration Journal

Customize a plain date book or blank diary with your own daily affirmations, inspiring quotes, country music trivia facts, popular French phrases, or vocabulary words of the week. Like *apocryphal*: Look it up!

Photo Ops

Break out of the silver-framed motif for a moment. When it comes to sentimentos, think of holiday swag: Not the laurel and pine variety, but the promotional merch for corporate America, like baseball hats, key rings and mugs, the kind you find advertised in the back of in-flight magazines. A corporate family watch with your family logo! Your own family merch can be created at pretty much any big photo developer. Order a calendar full of family snaps—you jumping moguls for January, your perma-tan sister shacking out by the pool as the calendar girl for August. If Dad's obsessed with coffee, make him a basket brimming with espresso chocolates, biscotti for dipping, a bag of beans, and the centerpiece—a collection of six "Your Family Name Here" collectible coffee mugs. Each emblazoned with an image of a different family member's photo. So Dad can switch from daughter Debra to dog Rollo, depending on who might cheer him up before his first sip of java in the morning.

MIRACLES ON SEVENTH AVENUE

THREE MAGIC HOLIDAY WORDS ARE
"SEND IT OUT"

Whether it's the story of loaves and fishes or Hanukah oil that lasted eight nights that inspires you, work a few miracles on the humble resources in your fashion closet. That fur you inherited scares you every time you look in there, so hunt for a furrier who does alterations and can cut that pelt into accessories for all the foxes on your list: a collar, a muff, trim on a cashmere turtleneck's cuffs, a pair of pillows, with enough leftover for a scarf for you. See if they can dye the fur into happy holiday colors.

Slice and dice a cast-off sequin skirt into party couch cushions backed with satin, or a Christmas stocking that'll turn Santa's head.

And the hand-me-down a Pucci muumuu? After getting over the shock that Mother did wear this once, have a tailor cut and hem the swirly fabric into a sarong and head kerchief, paired with a copy of *Valley of the Dolls*. If you're really nervy you could even gift it back to Mom.

Adult Entertainment

"What'd you get Uncle Buzz?" "I got him a really fun sweater!"

Sweaters aren't fun! Neither are ski goggles, even if Little Bro loves skiing. It's thoughtful to try to cater to someone's needs and hobbies, but how about stretching the definition of "need"?

If Uncle Marty always harbored the fantasy that he could have been a novelist, get him a weekend seminar for fiction writing. While you're at it, sign up yourself. The gift will go over even bigger if it involves spending time learning to do something with you.

Don't feel bound to preexisting hobbies. Introduce something new and exciting to try. Could be as simple as a day

pass to Great Adventure to get back on the roller coaster. Shop in the Classifieds, where they list all kinds of stuff you never knew you always wanted to do. Singing lessons, golf lessons, an old Ping-Pong table—a wok workshop. Bulletin boards at bookstores and art supply shops have lots of inspirations, too. Then all you need is something to make the intangible gift tangible—to get the adrenaline pumping. . . .

Twelve Play Days of Christmas

On the first day of the holidays my true love gave to me a sketchbook, pencils, and an art book of Edgar Degas.

On the second day of Hanukah my true love gave to me tap shoes and tix to the Savion Glover show.

On the third day of Kwanzaa my true love gave to me a pair of needles, a giant ball of wool, and one free knitting lesson.

gift certificate
ONE
KNITTING LESSON

On the fourth day of Noel my true love gave to me a fencing foil and a Three Musketeers bar. . . .

On the twelfth day of Christmas, my true love gave to me: Ice skates! And a thermos full of hot cocoa. Guitar, picks, a chord book; a bowling ball and shirt with my name on the pocket; a pool cue and case, and a video of Paul Newman's *The Hustler*; a radio-controlled race car and an invitation to goooo to the traaaaack.

BASICS TRAINING— HUMDRUM CONUNDRUM

NECESSITIES ARE THE
MOTHER OF INVENTION

We admit it, loved ones need socks. And since you're out shopping anyway, this is the time to buy them. As long as you transcend the generic, to make them seem more gifty.

Monograms are one way to transcend. Three little initials and suddenly you've personalized socks, gloves, umbrellas and elevated basics to elegant gift status. For less chic and more cheek, monogram the item with some other three-letter word: DAD on the pocket of the Brooks Brothers pajamas, MOM on the breast of the terry robe. JOG on the CD walkman case. LUV on that oxford shirt pocket. ZZZ on the pillowcases. A pet collar stitched with DOG, CAT, PET. Dishtowels that say DRY. Oven mitts that say HOT. Thumb

through the dictionary and see what inspires you. The same place that does monograms usually can do other kinds of embroidery. A stack of handkerchiefs that say ACHOO!

PRANKS FOR THE MEMORIES

One more way to make practical gifts less boring is to make them a practical joke. Anything in bulk is funny. Say your brother is known for running out of underwear. Giving him one pair might elicit a snigger. You'll get a bigger laugh from a huge box filled with a month's supply: boxers, briefs, a pair of girls' panties—how'd those get in here?—a pair of BVDs customized with a laundry marker: "What a Bum."

OLD AND WEIRD, OR COOL?

Vintage shops are a *terrific* place to pick up trinkets and accessories that are often not that expensive but are *really* stylish and *original* . . . or so you thought before your little cousin looks up from that Mexican peasant blouse and says, "I don't get it."

It can't hurt to beef up the vintage treasure with a bit of historical context by pairing . . .

- a cute fifties' purse and a copy of Audrey Hepburn's *Sabrina*.
- a vintage scarf and the classic mini book *101 Ways to Tie a Hermès Scarf*.
- sixties' rain slicker and a bio of Twiggy.
- aviator sunglasses and a bio of Admiral Byrd.
- a little girl's flowered "you can't stop me I'm running away from home" suitcase, with a toothbrush and a copy of *On the Road*.

GET LIT

Books and booze. The old standbys are always tasteful. But these are also two great tasteful gifts that taste great together. Like the Reese's Peanut Butter Cup phenomenon: Pack a bigger wallop by pairing the hard covers and the hard stuff.

Wrap up a great book, say a bio of Winston Churchill, with a bottle of wine, and you transform a dry gift into a decadent evening. Inscribe the inside: "Something to pour over." A bottle of sambuca and a *Godfather* DVD.

Speaking of chocolate, the Reese's concept can be applied to a bestseller and a box of Godiva's, a frothy romantic novel and a bottle of bath bubbles.

A QUESTION FOR THE SAGES

Can gift certificates ever seem personal? Absolutely. Just push the envelope with a . . .

Trip to Heaven. A getaway straight up into the clouds: skydiving, a parasailing ride over the East River, a helicopter cruise. Or a new car—for a weekend! Give a rent-a-car certificate. Make it a convertible.

Odds are any gift certificate, even for the record store or the sporting goods emporium, will seem more exciting if it's delivered in something less flat than an envelope. Put the music store certificate in an old LP case. Roll up the spa certificate and deliver it as a message in an empty shampoo bottle. Fold the tip money neatly into a change purse.

Seek and Ye Shall Find: Hide the money somewhere they'll find it later. Twenty bucks on page 300 of that Jack Welch book you bought or wrapped in plastic and baked in a warm, yummy fruitcake!

THERE IN SPIRIT

Whether it's for a relative who can't make it into town, or one who just spends the whole visit claiming, "I never see you," keep in mind . . . *you're just a phone call away from thoughtfulness.* Speed dial 1-800-Connect.

- A year of monthly flower deliveries.

- A year of prepaid long distance phone calls.

- A year of cable television for your mom who doesn't get HBO.

- There are so many food delivery services now, scrap the fruit basket and send something more symbolic:

 a bagels-and-lox care package for Grandpa Zucky, just like you used to have together every Sunday before he moved to Ft. Lauderdale. An annual steak and lobster dinner that you know is Dad's favorite cholesterol binge.

A TISKET A TASKET, LOSE THE GIFT BASKET

Even when they're filled with luxury muffins or exotic mushroom spreads, they can seem a tad impersonal. Maybe the problem isn't with the fruit, nuts, or muffins, but with the basket. Use some other kind of container, one that might, in fact, inspire the whole gift.

- Ice bucket stocked with a bottle of champagne and a box of Mr. Bubble.

- Laundry bag stuffed with thirty pairs of underwear, a box of detergent and rolls of quarters.

- A case of empties . . . and a beer-making kit. Be sure to tell 'em how you worked really hard on their present.

- Vintage vanity case holding soaps and bath unguents.
- Top hat with *Willy Wonka and the Chocolate Factory* and lots of jawbreakers, gobstoppers, and circus peanuts for packing material.
- Straw hat filled with seeds and gardening clogs. And a bottle of tequila with a worm.
- Life of the Party kit: Traveling salesman suitcase with luggage tags with your name on it. Inside, a couple of good CDs, balloons, drink recipe book, deck of cards, joke book, noisemakers.
- Take a Chance Beauty Box: Decoupage the cover of any cardboard box with beauty images from wild fashion magazine shoots. Pick makeup your recipient would never normally get: Violet eye shadow, glitter spray for hair, bright red lipstick, fake beauty marks, false nails, rhinestones to glue on, false eyelashes . . .

REGIFTS OF THE MAGI

When did regifting become a dirty word? Before *Seinfeld*, this venerable tradition was a completely respectable alternative to spending money. Here's to Old Traditions! The catch is for the regift to have meaning. You have to be giving away things you actually once wanted.

Instead of going to the bookstore, dig up your old copy of *Black Beauty* and other childhood classics for your little goddaughters, one of your old rings for your sister-in-law, a bunch of favorite games for your brother's new apartment—like that old leather backgammon board he used to beat you on. Then wrap up the dictionary and give it to your dad for old times' sake.

HOSTESS GIFTS

A Swell never arrives at a party empty-handed. In December, more than ever, you have to put some spirit in the spirit bags. Make your entertaining gifts entertaining. A bottle dressed up with a good luck horseshoe, Christmas crackers, a dreidel, a hostess tiara, mistletoe tied around the neck. A game—checkers, chess, Scrabble, Boggle and a snack—a tin of homemade cookies, or a box covered with the word "Joy," filled with Almond Joys. A flying saucer sled loaded with Hostess Snow Balls or other treats. Bring a disposable camera, ribbon, reindeer antlers, and a Santa cap. The day after, send your hostess a gift/thank-you note: a stack of Kodak moments, guests posed as Rudy and his naughty elf, neatly wrapped with a bow.

NICE AND NAUGHTY

Get a jump-start on Valentine's Day by buying your significant other an unexpectedly romantic gift. Something nice like two bone china cappuccino cups for indulgent Sunday mornings. Or naughty One Hot Night gift-with-purchase taped to a Duraflame log. Or a coupon for a make-out session folded inside a canoodling afghan, embroidered "Me" on one side, "You" on the other.

Not so Silent Night–ificate: Write a letter from the North Pole to your guy, telling him you've heard he's been naughty, not nice, and you'd like to talk to him further about this, at his place, sometime after the New Year. He should pick the night. Sign it Mrs. Claus. P.S. I'll bring the toys.

BE AN ANGEL

You've checked your list twice. Everyone's accounted for, you think complacently, lugging the holiday trim box back up to the attic. Then suddenly you stumble on your old copy of *Little Women*. Hmm, the page is open to the part where Marmee has the girls pack up baskets to take to the needy widow on Christmas morning. Jo, Beth, and Meg all decide to give up their own cream and muffins to give to the widow's children—even selfish Amy.

Gee, being so wrapped up in wrapping paper, you forgot about that more noble kind of giving. Resolve this holiday you'll try to perform some small act of saintliness.

It could be as simple as a check to your favorite charity, or donating a few hours to read to children at the library. But it could also be something that doesn't require someone else's official organization. Be generous by inviting three people to your holiday party who normally you'd overlook. Add angel dust to your usual do-good routine by dropping off a fresh

batch of holiday cookies at the police station or firehouse. When doing your biannual closet-edit, bring the fashion rejects to the Salvation Army. For extra wings, throw one thing onto the "don't need it" pile that you might not have been quite ready to get rid of. Then be sure to buy yourself something at the Salvation Army store. You deserve it, and it keeps their cash flow flowing.

Love, Anonymous. In Sweden, they have a tradition, called the *Julklapp*, of wrapping a small precious gift in a huge box and leaving it on someone's doorstep. Give secretly to people in need whom you know! Rumor has it your little sister bounced a rent check recently. Maybe you wire a small mystery bonus into her checking account. Santa would approve. Saint Nicholas was really a lean and wealthy bishop who lived in Lycia in the fourth century. He developed his reputation as a legendary do-gooder for secretly giving away money to young maids in need of a dowry.

Chapter 2

Gift Wrap

Roll Reversal

What Swell girl's pulse doesn't quicken at the sight of a robin's-egg blue Tiffany box or a burnt orange Hermès bag with her name on it? Ladies, take note. Mr. Tiffany and Monsieur Hermès spent a lot of time and attention perfecting their packaging. So should you.

Of course, a Swell girl doesn't exactly use the Oxford English definition of "perfect." When it comes to crisply creased corners, starched organza bows and invisible tape that's, well, invisible, let's just say she'd never cut it in the wrap department at Saks.

No matter. A swell wrap artist has other gifts. A talent for combining high gloss with a few rough edges, a passion for recycling, and a high tolerance for glue stick.

Humble Beginnings

If it's all too fancy—foil paper *and* glitter gift cards—the lavish touches get lost. Turn up the contrast. Start with unexpectedly plain paper and the other extravagant or artistic flourishes will stand out that much more.

Brown Bag It

Dress up brown parcel paper with splurge-y striped grosgrain ribbon, or a string of jingle bells, a heart cut out of felt—a heartfelt touch. Cover it with too many one-cent stamps and write, "Do not open 'til Christmas."

Blank Canvas

Design your own paper on white shelf paper or butcher paper. Whip out the watercolors, and paint something as simple as a basic kindergarten Christmas tree, and trim with glued-on "strings" of sequins, big paillettes for "ornaments." Or go more abstract with a swirly, glittery, Jackson Pollock-y design, and give it a title like "Winter Solstice."

Say It with Words

Borrow a line from a poem or a song—". . . not a creature was stirring, not even a mouse"—written in silver pen on midnight blue paper and a few stars. A single word will do as well—"Merry"—either big and graphic or spelled out over

and over all over the paper. If there are multiple gifts, do an M on the first, an E on the second. . . .

In the Bag

A good gift bag is a cut above the average shopping bag. So get your scissors. If you have a bag with fabric handles, snip them in half and tie the ends into bows. Remove a logo by cutting it out, then lining the bag with colorful tissue paper. Make the shape a peek-a-boo circle, or if you're good with an X-Acto knife, try an icon—heart, candle, exclamation point, or question mark under which you write, "You'll never guess."

Alternative Wrap

Sheet music, wallpaper scraps, comics, subway map, dictionary pages, etiquette pages, a Chinese menu, a movie poster, pages from *Playboy*. Just the articles, of course!

Teariffic Idea

A favorite Victorian holiday decorating custom was using "scraps," small images of dolls, flowers, lacy pretty things, pasted down in a pattern to dainty up a box or ornament. Moving into this century, collage together artfully torn magazine headlines, postcards, or a picture of the Rockettes defaced with Keith Haring–style graffiti doodles and your message: "Hope you get a kick out of this."

The Wrong Box

Do an ode to Warhol by appropriating works of classic commercial art: an emptied-out box of Cheer detergent, or a box of Tide you've doctored to read "Yule Tide." Lift and reuse a Joy dishwashing liquid label: "Joy to the world." If it's cardboard, it'll work: a Monopoly box, take-out containers, a FedEx box, a cereal box marked

"special offer inside." Or put the prize in a box of Cracker Jacks—think of the fun of emptying all that candy-coated popcorn.

Don't Scotch the Tape

Why does tape always have to be invisible? Stick on silvery gaffer tape, electric blue painter's tape, or masking tape with your message Sharpied on it: "For U and only U." Or, "S'prise s'prise s'prize." Or, "If you don't like it, you can return it."

Scrap the Paper. Fabricate!

Cut up a forgotten tablecloth or napkins, or a couple of yards of gingham in different colors, and tie the package up, hobo style.

Fold a T-shirt

Like an "I heart NY" tee. Put the package in the T-shirt, tuck in all the edges to make a nice neat laundry bundle and safety-pin it all in place.

Kite Ribbon

Take scraps of fabric, rip them into one-inch-wide strips, and tie them together end to end so they form one long

patchwork "ribbon." Apply the same concept to all your real ribbon scraps.

Ribbon Alternatives

Shop at vintage stores for gift trim: silk flowers, tassels, braid, lace, odd lengths of ribbon, or just use . . .

- Bright shoelaces tied in a bow.
- A ribbon belt hooked into place.
- Draw on the bow with Magic Markers or good old glue and glitter.
- Licorice whips.
- Sprigs of evergreen.
- Sleigh bells.
- Twine. Wrap it around and around and back and forth until you can barely see the paper underneath. Like the way Christo wrapped the Pont Neuf.
- A satin ribbon tied to either end of a tiara.

HOW TO TIE ONE ON

Whether it's for gifts or tree plumage or an impromptu fashion accessory, one skill a holiday swell must master is tying a decent bow. Do two knots so the ribbon around the package is tight. Now for a few loopier versions . . .

The Original Bow

1. Start with one foot of ribbon.
2. Make a flat loop. Pinch it between your thumb and forefinger.
3. Wrap other end of ribbon over your thumb, reverse side out.
4. Make another flat loop while holding on to the first one. Slip second loop through the first, pull to tighten.

A Fluffy Bow

Pinch the ribbon and make your first smallest loop, leaving a tail as long as you like. Keep making loops—round and round—bigger and bigger—until the bow is full.

Fix the center of the bow with another piece of wire.

Cut the "tails" in points, or off altogether.

Floof! Meaning, lift and arrange loops to fluff up the bow.

The Pom-Pom Bow

To get the most pouf, use a wire-edged ribbon for this one.

1. Start with three yards of ribbon. Wind the entire three yards around the palm of your hand.

2. Slip the ribbon off your hand while keeping it wound up.

3. While holding the stack of ribbon, cut a notch on either side of the center point.

4. Tie a small piece of ribbon around the center where you made the notches. Separate the individual loops and puff them up and out.

OPENING NIGHT

All that effort into making your packages look beautiful or cool, then on opening night—kaboom!—before anybody even got a chance to notice, you find yourself buried in a pile of paper rubble. There must be some way to make the gift-giving portion of the holiday last a little longer, without getting a reputation as the spoilsport who made all these *rules* for opening presents.

Faking It

Try to get the family to open gifts one at a time on Christmas morning and you haven't got a prayer. Christmas Eve, how-

ever, has a more civilized air. Establish a tradition of champagne or hot punch and hors d'oeuvres by the tree. To hold the group's attention, add a few funny fake-out gifts. Stick on gift cards with the TO: filled out but the FROM: left blank. These weird, ridiculous, anonymous joke gifts are not only funny to give, but fun to collect. A superbly horrendous elephant vase from a tag sale, electric nose-hair clippers advertised on TV.

Another way to build anticipation is to turn the opening festivities into a simple game of Spin the Bottle. Use a plain or holiday decorated bottle to see who gets to open one next.

Hide and Seek

Spread the gifts out by hiding them all around the house. Kids and parents can search for them like eggs on Easter or afikomen matzoh on Passover.

The Box Stops Here

This game is similar to musical chairs, where everyone is seated around the table and gets a gift. When the music plays, guests pass the gifts around and around until the record stops. Then whatever you've got, you keep and open. This game works best if you mix some beautifully done-up gifts with a few obvious dogs, like a banana with a stick-on bow.

Chapter 3

You've Got
Holiday Mail!

To: Santa Claus
North Pole
Hemisphere

Dear Reader,

How great is it to flip through the bills and come across any handwritten envelope that's not from your parole officer?

Greeting cards are aging faster than any other holiday tradition. These days, as e-greetings let you get away with the bare minimum, sending anything with a stamp on it seems positively quaint. So if you put a little extra zip into the zip code, you know that card's going right in the center of the mantelpiece. How much DIY you want to get into is up to you. Customize a store-bought card or start from scratch.

It's your message. If you get religious inspiration in December, send out a psalm. If sledding in nature is your idea of a spiritual experience, make it an ecumenical wintry theme. The point is just to send some warm cheer through the chilly season.

P.S. No reason everyone on your address list has to get the same card. If you have a new inspiration midway through, or run out of blue glitter, so what? That's what happens to artists, and it just makes the cards all the more one-of-a-kind.

P.P.S. If you're taking the occasion to be two-dimensional but deep and plan to write a personal message on the card, keep a scratch pad on hand to formulate the thought first. That way you can adhere to the one steadfast rule of Swell greetings: No cross-outs!

DIY LEVEL 1: CUT AND PASTE

Gluing

- A heads-up penny to a blank card: "Good luck in the Next Year!"
- A candle: "May the season glow with happy thoughts." Or, "Hope your holiday doesn't blow."
- A sprig of mistletoe. Inside, cover the card with lipstick kisses.

Hole-punching

- Punch a pretty blank card with lots of holes. Inside, write: "Happy Hole-y Days."
- Punch two rows of holes down the center of the card and lace it up sneaker-style with a ribbon or shoelace.
- Punch two holes, one at the top and bottom. Push through a big piece of ribbon and tie a bow in the middle of the card.
- Punch one hole (now that your hand's tired) at the open end of the card and tie it closed with a small piece of ribbon or yarn. Cute.

Scissors

While on hold, or commuting, some people knit. You cut. "It's a Small World" paper dolls, angels, or any abstract design you think looks like a snowflake. Inside write "Have a Cool Holiday."

Matchbook

Paint the matchbook so it's pretty for holiday candlelighting with easy stripes or a holiday icon like a bell or a Star of David for Warm Holiday Wishes.

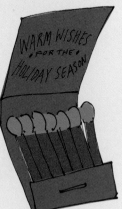

Customize a Coaster

And the greeting. Some get a "Let's raise a glass in the New Year!" For those you don't plan to bend elbows with just write "Holiday Cheers!"

Hotel Stationery

Purloined from places you've stayed at throughout the year. On it write a letter filling in friends and family on some funny story that happened to you over the last twelve months but that they might not have heard, particularly if you've been a frequent traveler. If you're still too busy for that just dash off: "Hope your year is as good as room service."

Ransom Note

Paste down a photo of your favorite fat man—Jerry Garcia, John Candy, Fatboy Slim—and inside write, "If you ever expect to see Santa alive again . . ."

IF YOU EVER SEE SANTA A

We Are the World

Cut a piece of a world map to fit the card, paste it down and draw a peace sign. The message: "Peace On Earth."

Rockwell & Rauschenberg

Make a collage of the Perfect Idyllic Holiday scene with scraps of images. A sled, a puppy, a crackling fire. Victorian

EXPECT TO LIVE AGAIN

Christmas tradition was to use "scraps" of images of dolls or flowers. Those were bitsy and lacy; yours can be more modernist. Cut up a traditional holiday card or bucolic winter images in the shape of a Christmas ball, a candle, a tree—to form a mildly ironic but still festive holiday icon.

THE POSTMAN ALWAYS RINGS TWICE, OR THREE TIMES

If you're too delinquent to get your cards out in time for December, don't beat yourself up for buying all those stamps. Send out New Year's cards. If you still can't get it together by January first, give yourself another month reprieve, 'til Valentine's Day—at least the red ones will still work.

Recycle

An old gardening book, or magazine, with great photos. With an X-Acto knife, cut images of gardens, flowers or foliage to fit a piece of cardstock. On top of the pic write in paint, Magic Marker, or glitter an evocative word, "PARADISE." Inside: "Wishing you a season of earthly delights." When it comes to season's greetings, what seems seasonal is highly subjective. No need to feel limited to menorahs and Christmas trees. People only started sending Christmas cards in London in the mid-nineteenth century. Before that they exchanged handwritten holiday greetings in person. The first commercially printed card was commissioned by Sir Henry Cole, better known for modernizing the British postal sys-

tem. In 1843 he commissioned an artist to produce a triptych: each of the two side panels depicted a good deed, clothing the naked, feeding the hungry. And in the center, a party of adults and children with lots of food and drink. It was inscribed: "Merry Christmas and a Happy New Year to You." The tradition took thirty years to come to America. When it did, the rage was for high-quality cards with floral arrangements: roses, daisies, gardenias, and apple blossoms. And cheap penny postcards imported from Germany.

Shopping

ABC

Chapter 4

Always Be
Christmas/Hanukah Shopping

A Swell girl has a reputation for being kind of—how should we say?—*laissez-faire?* It's a point of pride that she can cavalierly leave things 'til the last minute, then in a flurry of breathless ingenuity, pull it all together.

This is not one of those times.

Holiday shopping is like looking for a relationship. You never find the prize when you're prowling for it. It has to hit you by surprise, when you least expect, when you're not even looking. Which is why this is one occasion where a Swell girl plans ahead.

Start with a list. In January!

Just fold that list up and put it neatly in your wallet. The key to maximum gifting with minimum effort is to shop all year long. (That'll also avoid acquiring a national debt in December.) Don't think—buy. The unconscious multitasker, you stockpile trophies for the gift closet at the oddest places, in unexpected moments, when you were killing time at the airport souvenir shop, fondling lotions in the spa waiting room, or . . .

On vacation. When else are you this relaxed and shopping? You're wandering into markets, roadside stands you would never stop in at home. So if you're lucky enough to take a vacation before November, prick up your antennae. Take time off from the churches and museums and you could knock off your whole list before you get back on the plane. The itinerary below is where you find all kinds of local treasures that are often amazingly inexpensive. But no one needs to know that!

Airport Shops

Doesn't have to be somewhere exotic. They have Eskimo crafts on sale at the airport in Minneapolis. In Detroit, pick up a Motor City charm for your kid sister's bracelet.

Department Stores

Mid-level stores in foreign cities are where you find brands and local goods that you can't find at home, and priced to move. In Finland, mohair blankets for thirty dollars. Get them to ship it home and you don't pay sales tax.

National Tourist Shops

They sell government-subsidized crafts, which if you're in County Cork means cheap handmade Irish sweaters and plaid scarves and blankets.

Mom and Pop Shops

Non-designer stores on the side streets often sell the high quality stuff locals buy, like neat spaghetti tongs in Florence or no-logo leather gloves. Brand them yourself—having the giftee's initials monogrammed at the wrist.

Flea Markets

In Paris or Saigon, always ask the tourist office or concierge where the big fleas are (besides the ones in your room). That's where you clean up on pottery, spices, silks—you're a veritable Marco Polo.

Jewelry Shops

Every country has some native stone—amber in Poland, rubies in Thailand—affordable enough for local artisans to come up with unconventional designs you won't find at your local Harry Winston.

Little Old Ladies with Stalls

Lace handkerchiefs in Portofino, each hand-embroidered with a single initial. After you pick up one for yourself, buy a J for Aunt Jane . . .

Archaeological Dig

Giant fossils and framed scorpions in Morocco—ew! But wait, what about for the nephews?

Postcard Stands

Don't send them, save them and use them as gift cards on which you write, "Thought of you in Belize." This explains where the gift is from, which is good because even if your neighbors can't quite wrap their minds around the framed butterflies, at least they're flattered that you had them in mind. And they know it can't be returned.

BUY IN BULK

Rationalizations: It's a popular myth that you have to get everyone something different. Individuality isn't always what it's cracked up to be. Holidays are about celebrating group identity as much as anything else. Getting everyone the same thing can be sort of a team gift for the family. Like Super Bowl rings. It helps if the item is somehow exclusive so only your team has it.

Concerts

You scored the hot tix to the White Stripes. On the way out, pick up concert tees for all the kids, and the parents, too.

Book Signings

When Hilary Knight is making an appearance at the local bookstore, meet the illustrator of all your favorite *Eloise* books, then whip out your list and get him to sign copies for every one of your girl cousins—and a few extra blanks for new arrivals.

A silver key ring, money clip, bookmark—on their own they're classic who-cares tchotchkes. But get it together early enough to have them engraved with some family maxim or joke and they can become heirlooms. Silver napkin rings with everyone's initials or childhood nicknames that they can leave at Mom's, or wherever the big family dinners take place. For your favorite guy friend, an ID bracelet with your pet names.

SHOP WHERE YOU SHOULDN'T

Go into stores you would never normally consider . . .

- Vintage T-shirt shop: Spy a Bjorn Borg tee for your tennis freak brother; an "I'll Bet on Merv" casino shirt for your blackjack-loving dad.
- The Chocolate Store: You didn't even know they made pink hot chocolate, but there's a six-year-old on your list who's gonna flip.
- Pawn shops: Funny how those gamblers never seem to come back for their horseshoe pinky rings. You're in luck, they'll make great friendship pinkies for your sister and BF.

SUPER LUXURY STORES

A swell girl's only human. Yield to temptation and go to Fauchon, Hermès, Christofle. Set a budget and get whatever you can afford there. Sometimes the small things are the coolest: A pair of ivory and sterling chopsticks at Christofle. Smythson's little black books. A bar of glycerin soap big enough to lather up a horse at Hermès.

Holiday

à la Mode

Chapter 5

Trim Yourself

The stairway's swathed in velvet bows, the windows are flashing lights like a cheap motel—even the turkey's wearing frilly booties. You're *not* slinking out of the house in that same old safe black camouflage. Turn up the *oomph* meter!

Put a little ho-ho-ho in your look. And not with one of those bad Christmas sweaters. There are more flattering ways of jollying up your fashion side. Sex appeal with a sense of humor. Seasonal sugar and spice. Cocktail parties and office bashes are full of bosses winking, champagne fizzing, red cheeks glowing—so if ever there was a time to be daring. . . .

Just in case there's a punch-bowl moment with that sexy senior VP, start with something that you know always looks great, and then throw in the trimming, a flash, a plunge, anything to add some jingle.

Over-the-Elbow Gloves

In satin, or kid leather. With rings, and chunky stacks of bracelets. A sprig of Holly Golightly.

Not-So-Silent Tights

Colorful hosiery to glam up the gams. Make a plain dress mod—*très* Courrèges.

Brooch Any Subject

Turn up the wattage with antique brooches, the more the merrier, flashing along the sightline of your décolletage, or on your spaghetti straps, even in the hair.

A Velvet Ribbon

Tie one around your neck, around the waist of a dress, in lieu of a belt, or replacing the leather strap from your T-strap shoes and tied in a bow.

Gold Shoes

Or any brightly colored heels, especially metallic, will catch the light.

Pump Up the Pumps

With shoe clips. Velvet rose clips found at notion shops.

Sleigh Belles

Cover the whole front of a dress in jingle bells.

KNEE-O-CONSERVATIVE

The easiest way to revamp a conservative look is just to cut it short.

Make a kilt a mini and switch the kilt pin for a brooch. With a pair of black boots, now yer "Elfie," Santa's naughty helper.

An antique Victorian lace nightgown chopped to a length that would make Prince Albert blush, especially worn with red tights and heels.

Dress for Succexxx

If you're a suit girl, you don't want to look like you just walked out of the bored room. Wear one with nothing underneath. Just tons of glass beaded necklaces. Or earrings that look like you're swinging from the chandeliers.

PULL AN OUTFIT OUT OF A HAT

A tiara. Top hats, a bowler, a Dickensian newsboy cap—any of these will magically transform even the most uninspired outfit into the photo-op look in the room.

DON'T FORGET YOUR BAG!

Replace the everyday handbag handle with ribbon, a men's tie or long skinny silk scarf neatly knotted. Take a leather shoulder bag and hand paint a message: HIPPIE HOLIDAZE. Buy a plain clutch and customize it with some sequin appliqués. Or cut up a feather boa and stitch it onto the sides, so it's all fluffy and tickly.

E-Z BAKE OUTFIT

"$#@?! Josh, they're heeere!" When you find yourself un-primped and your guests prompt, reach for the classic fashion fix-all: the cocktail apron. Tie on one of those cute vintage aprons with the embroidery whether you're wearing a sheath or jeans. Lipstick, pearls? You're done.

HOME STYLE

People get confused when they have to dress up to stay home. Have we mentioned reindeer sweaters? Whether hostess or guest, wear what you always wear to hang out—albeit taking a few liberties. Why not? You're not going out.

- T-shirt: Dressed up with a "fir" (fur, that is) scarf or collar festooned with ribbons.

- Jeans: Belted with a big satin ribbon pulled through the loops and tied in a bow.

- Open-toe glittery sandals: Do them with your trousers, jeans, even warm socks.

- Cardigan: Change the buttons to rhinestone or pearl. You could cut the buttons off altogether and thread a ribbon through the holes.

- Kimono: Hemmed to jacket height, adorable over a sexy something, jeans and heels.

- Pajama pants: With a camisole and cashmere cardie.

- Cool jeweled slippers: Made chic with skinny black cigarette pants and a black satin top.

- Vintage nightie cinched with satin ribbon at the waist and heels and a decadent necklace.

- Caftan: Sexy sandals and chandelier earrings are required if you want to pull this off like Bianca Jagger.

Don't Leave Home Without It

If you're going to invest in one thing for yourself, add to your fashion portfolio a sexy coat. A silver quilted trench, a bright-colored sixties' car coat, vintage fur jacket, anything cute enough that you can wear it to a party and never take it off. It'll make its money back on all the times you forgot to take your dress to the dry cleaner.

It's What's Within

Well, if you can't get it together to look festive on the outside, at least you can feel it on the inside. Crazy Christmas underwear! And watch out for that guy with the mistletoe belt buckle and X-ray vision.

That Counts

Chapter 6

Decorating

Don't get us wrong, we *love* fresh pine wreaths with red bows and that electric menorah in the window. But we were just wondering . . . do decorating traditions have to be so, um, traditional?

A lot of the ye olde traditions we now take for granted were actually new-fashioned ideas not so long ago. Take Rudolf. He was born only about sixty-four years ago, in 1939, when Mays and Co., a department store of yore, commissioned a poem to hand out to shoppers as a holiday promotion. Now he's right up there with Santa Claus, who, by the way, was originally a lean Turkish sailor before he was drawn as a roly-poly, rosy-cheeked fellow by cartoonist Thomas Nast in *Harper's* magazine in 1881. Christmas trees were merely a quirky German tradition until Queen Victoria married Prince Albert, a German who insisted on introducing Tannenbaum to Merry Olde England.

A Swell holiday hostess adopts some traditions, adapts others and then invents a few of her own. Here are a few ways to loosen up some of those neatly tied red bows. . . .

TOP TEN TIPS
FOR RE-DECKING THE HALLS

Move the Twinkle Lights

From the tree to some part of the house that needs brightening up. String them along the buffet, or around the window on the inside. Tack them to the wall and spell out a word that sums up the spirit: H-A-P-P-Y; L-O-V-E. Shape them into a star, a heart, or an abstract constellation you call "Northern Lights."

Re-Spin the Holiday Albums

Too bad no one listens to that old Perry Como LP, or any of those other classic Christmas albums. The covers used to be so much fun to look at. Put them on display, fanned out on the coffee table, or on the wall, stuck with double-sided tape.

Gift-Wrap the Furniture

Tie wide satiny ribbons on the throw cushions, and scatter a few on the floor like presents. Instead of a table-cloth, wrap the dining-table top in paper. Even plain white would be nice. Fold and tape the corners as you would a real gift box. Then run another wide ribbon down the cen-ter and across and tie the

ends into a huge bow, turning the table into one big gift.

Repurpose the Good Stuff

Bring out the odd pieces from hiding—a silver tea service, crystal champagne flutes—and find them a new use. Fill the flutes and pots with flowers, the teacups with candy.

Build a Roaring Fire

Buy a tape of the yule log and leave it on. Stick the TV in the fireplace.

Remodel the Gingerbread House

Give it a modern renovation. Rice Krispies treat bricks mortared with Fluff for that sleek, squared-off Philip Johnson look.

Artist Will Cotton built this cookie house with a Swiss chalet in mind, to use as a model for one of his paintings.

Try a New Color Scheme

Tweak the old red and green into hot pink and lime. If you can't bring the Swell girl to Palm Beach for the holidays, bring Palm Beach to her.

Designate a Photo-Op Spot

A chair with a Santa hat, a white beard and mustache, and a Polaroid camera, where guests come and pose.

Stockings

Have one for each guest.

Make It Snow

With snow globes lined up on the window sill.

One Long Ribbon

Trailing from outside down the hall, through the kitchen, up a banister, along the floor, all the way to the tree.

AND THE NUMBER ONE SWELL HOLIDAY TIP FOR RE-DECKING THE HALLS . . .

Hang a picture of Jolly Old David Letterman on the mantel and tell all your friends he's the real Santa Claus.

TRACING YOUR FAMILY TREE

BACK TO ITS LAWLESS PAGAN ROOTS

The custom of dragging a pine tree inside the house during Christmas is believed to have begun in Germany in the first half of the 700s, and involves sketchy tales of trying to convert druids and . . . never mind. It took a while to catch on in America. The Puritans would have none of it. People would be fined for hanging ornaments on trees, penalized for not taking the holiday seriously enough.

Even today, the best trees have a spirit of lawlessness. Branches piled with candy canes, kooky Christopher Radko figurines, the string of macaroni your brother made in kindergarten and still makes Mom misty. A very merry mess. But there's nothing wrong with pruning back a bit, just to keep it fresh. Encourage a spurt of new growth. Maybe not a whole theme, but a motif. Instead of tinsel this year, maybe some silver spray paint on the needles, or keep all the sentimental ornaments but replace the generic glass bulbs you use for filler with fruit, apples of all sizes and flavors.

Not too "designed" or it'll look as uptight and personality-free as the tree in the mall. Like the first Victorian trees, with their gilded walnuts, candies, and rosy-cheeked dolls, keep it sweet, and a little nutty.

Wrapped Gifts

Hang small packages from boughs by ribbon, and each guest can pick one.

Think Pink!

All pink glass balls. Mamie Eisenhower had one of these popular fifties' theme trees. Swap the usual tree skirt for a vintage circle skirt.

Bow Tied

Classic adorable way to dress a tree. Instead of ornaments, collect ribbon, lace scraps, or yarn bows. Tie them with long trailing ends. The more bows, the more dramatic. Tie on so many you could spend hours staring at the tree and still see new ones.

Antique the Tree

A few blasts of gold spray paint will give it a burnished sheen. And silk tassels swinging, and candles, like the old days. Just don't light up unless you're dating a fireman.

Ring-a-Ding-Ding

Collect bells all year, dainty silver bells, cowbells, a ceramic one with pink flamingos from the Florida trip. That way if a breeze blows when you open the door, a bunch of angels will get their wings.

Glow Sticks

In lieu of lights. The kids will rave.

Hello Dolly

An excellent excuse to rescue your old collection from the attic—the Madame Alexander, the paper dolls, the souvenir dolls your grandparents used to bring back from their travels. Edit out any crazy-eyed ones that make you think of *Chucky's Room*.

Edible Tree

Popcorn balls. Gumballs as big as a glass ornament. Gummy bears threaded into chains. Licorice bows. Sweet!

Adam and Eve

All kinds of apples and figs, and nudes cut out from an expendable art book, accessorized with drawn-on fig leaves,

unless you're planning on a blue Christmas. Bench the angel this year and put a wedding cake bride and groom on top.

Tiny Boxwood

On a table under which goes a heap of teeny wrapped gifts.

Topiary Reindeer

Get a pair of tabletop-size penguins, a reindeer big enough for the kids to want to ride. Or, a North Polar bear as tall as a tree.

Herb Forest

Can't see the spaghetti through the trees—big potted herb plants, thyme or rosemary, planted right down the center of the table. Decorate with bits of tinsel and tiny bulbs.

Palm Trees

Let's be honest, there were no fir trees in Bethlehem or in the desert town where the Maccabees kicked sand in the

face of the Assyrians and got the Hanukah story going. So this is a sexy idea for guests of all persuasions, including ones who wish they were taking the winter holidays in Miami.

Plant a Copse of Christmas Trees

Instead of just one jolly green giant, get three smaller ones, varying heights, mama, papa, baby. Or two trees, one at each end of the room like they did at Hearst Castle.

Most minimalist way to go. If you're short on space, lose the trunk and just get some branches.

White: One year Ilene made do with a bunch of those white painted branches they sell at the Korean market, stuck in a vase, with a silk red cardinal twisted onto the twig. So pretty she kept it around all winter.

Black: Once upon a December, Cynthia's grandparents decided a tree was old-fashioned and got a ten-foot-tall branch, spray-painted it black, covered it with lights, and wired it to a modern base. Then they hung ornaments on it like it was any regular tree, and saved it from year to year. Eccentric! Creative! Cynthia's still scarred.

Green: Mix a bouquet of yew, shiny ivy, and other exotic evergreens the florist's refrigerating, and arrange in a vase that's as tall and sleek as a tree trunk.

Mistletoe

The kissing bough. A circular evergreen brought in on Christmas Eve, with candles, red apples, ornaments, and a large bunch of white-berried mistletoe. Any girl standing under it was entitled to claim a kiss. In parts of England, the man was allowed to kiss the girl as many times as there were berries in the bunch, which in abundant years doubtless resulted in lots of illegitimate children. Just kidding.

MENORAHS

Hanukah is a Festival of Lights that involves lighting a nine-pronged candelabra for eight nights. On the first night, you light one candle and every night you add one more candle until all eight are ablaze. A proper menorah has to have nine lights or candles, with a slightly larger one in the center to light the rest. What those lights are made of, however, is up for grabs.

- 9 little lamps. To replace the electric menorah in the window.
- 9 champagne glasses with a candle in each flute.
- 9 luminary bags. Each one emblazoned with a wish.
- 9 birthday cake candles, the numbered kind.

- 9 tea lights set in a tray of smooth stones. Picked up at the garden supply store, or, even better, collected from the beach and shellacked. They could be kindergarten colorful. Invite the kids over to paint the stones with little naïf stars, messages, palm trees, olive branches, flames, or just "a design."
- 9 different candlesticks. Silver ones of all different heights and provenance.
- 9 flashlights.
- 9 big homemade candles—melted crayons, ice milk cartons, the works.
- 9 martini glasses holding lamp oil. Hey, someone did say it's made from olives, didn't they?

TABLETOP WREATH

If you can get over your irrational fear of going to the florist and asking for "foam-filled forms" (craft-gene people have

no problem with this), you will discover this is a really really really easy project. Just buy a foam ring and a selection of greenery, or pick your own if you have evergreens, holly, ivy, juniper, etc., in your yard—or in your neighbor's yard. Then run home, snip off twigs and stick them in the foam, going round and round 'til the whole thing is full and looks just like a real, actual, super-crafty wreath that you can put on the table or hang with a big wide satin red bow. Sometimes you just want to go totally trad.

DOOR DÉCOR

KNOCK THESE AROUND . . .

- Just a small red square that says HAPPY HOLIDAYS.
- Photograph other people's wreaths and put the prints on your door.
- A twig Star of David, tied by your favorite Boy Scout.
- Giant glass ball ornaments hanging from ribbon.
- White pom-pom heart wreath.
- A bundt-cake pan, with wreath berries and whatnot painted on the outside.

Revel-ution

Chapter 7

Overthrow the
Old Party Establishment

You can get the place all dressed up but a Swell house only really comes alive once you have people over to dive into your punch bowl. Small or big, a Swell holiday party can be inspired by whatever holiday themes you relate to: family, nature, cartoons about snowmen that make you cry. Borrow from different cultures, even pop culture. All the ballets, songs, movies and literature that supply those fond childhood memories and images can be fodder for entertaining ideas. It could be a whole blown-out theme, or just a detail. You invent a mean green Grinch Punch that makes everything look like Whoville. After a few years, any novel addition to the holiday canon will become as much an institution as ham and eggs-nog.

WHITE CHRISTMAS

Written in 1941 by Irving Berlin and sung by Bing Crosby in a voice smoother and richer than a quart of eggnog, "White Christmas" could be one of the most sultry holiday songs ever recorded. Turn it on, lie down, and start dreaming of a dreamy winter wonderland party.

The Setup

Chic, glamorous winter white. A white tree, decorated with icicles and rock candy. White drop cloths cover everything. Unfurl the fluffy white holiday Flokati. Toss white faux fur throws on the sofa for snuggling in the snow.

The Bar

Covered in a white lace tablecloth and lots of glittering cut crystal. Frosty vodka bottles nestled in glass ice buckets—chunky "diamond" cocktail rings mixed in with the rest of the ice.

The Cocktail

White Russians, served on white crocheted snowflake coasters.

The Buffet

At the center is an ice sculpture of an evergreen surrounded by serving dishes piled with shaved ice for shrimp, oysters on the half shell and the rest of the raw bar that the French call a *plateau du Roi*. Smoked salmon served with crème fraîche on baby potato pancakes (a Hanukah note in honor of Irving).

Window Dressing

Spray white snow on the panes of your ice palace, giant musical notes, one big snowflake, or the words "I'm Dreaming . . ."

The Hostess

Is in snow-bunny white, from her tiara white down to her white polished fingers and toenails.

The Fun

Sheet music from the song of the hour, encouraging lots of singing. On the telly, ski movies by Warren Miller.

Dessert

Hmm. . . . Baked Alaska or Mont Blanc?

PARTY LIKE THE DICKENS

Everybody has one. That movie you watch religiously season after season. You know the story by heart, whisper the lines aloud just before the actors do. Without it, the holiday feels oddly incomplete. It's not just a movie, it's a holiday tradition, as necessary as dragging in a tree, or spinning a dreidel. Hey, just cause it's Hollywood doesn't mean it's not meaningful!

Pomp up the ritual. Make it an occasion to get the gang together and have a screening party. Add some atmosphere that the hardcore fans will love and will help neophytes get in the spirit.

For our money, it's "A Christmas Carol." Not just any version, but specifically the 1951 black-and-white classic with Alistair Sim who, with apologies to Bill Murray, will always be the real Scrooge. It captures that quintessential old-fashioned English Christmas: lots of snow falling on Victorian houses, carols like "Hark the Herald Angels Sing" and brilliant Dickens dialogue, which can keep you glued year after year. Not least of all because with all the accents and cockney slang, it takes a few years to really be sure what they're saying. And it's spooky, not sappy, which makes it good for a drinks party.

The Setup

Arrange the living room for maximum viewing around the telly. Or go big-time by renting a video projector and a screen and make an at-home cinema. Lower the lights and fire up some candelabras. Turning the heat down a degree or two will set the chilly mood and encourage guests to cuddle during the scary parts.

The Bar

Everyone warms up with Hot Pink Gin Punch (page 140). Customize the cocktail napkins by inscribing them, alternately "Bah, Humbug!" and Tiny Tim's best line, "God bless us, every one."

Nibbles

Set out snacks that the Ghost of Xmas Past would approve of. Baby mincemeat pies (page 135) with a drop of cognac on each; roasted chestnuts. And a bowl of popcorn, because *it's a movie!*

The Buffet

Serve Pennypincher Soup. Beside the tureen goes a basket of bread and a small plate for coins—guests must toss in a penny for every extra crust. Then all you need is a platter of rotisserie turkey pieces and cranberry sauce, so everyone can wave their drumsticks by the time Ebenezer meets the cornucopic Ghost of Christmas Present.

The Guests

Top hats and wool scarves that guests can wrap around their necks or pull over their heads when the Ghost of Christmas Yet to Come shows up! Fingerless gloves: sexy! And good for stringing popcorn.

The Fun

Add an element of *Rocky Horror Christmas Show* to the festivities. Let viewers call out lines they know by heart. "Are there no prisons? Are there no workhouses?" Every time you hear the word "goose," pinch as many people as you can.

MISTLETOE AND PEPPERMINT

They go together when you think about it, for a late night, "after-dinner-mint party." With lots of mingling and minty-fresh kissing.

The Setup

Clean and sexy. Lipstick-red and white and candy-cane stripes. Don't skimp on the mistletoe. Hang it in plain view and in unexpected places, too. The coat closet, inside the fridge . . .

The Bar

Cover it in evergreens. Serve cocktails with names like the XO, Smooch, and Peppermint Smack. Cocktail napkins with lipstick prints on them.

The Buffet

Just a mountain of spearmint and candy canes in the middle of the table. And served on passed trays, cupcakes, each with half a playing card stuck on top. If you meet your other half, lead the way to the mistletoe!

The Funk

Rock 'n' roll to make-out music, anything that's got love or kissing in the lyrics. KISS and, of course, Chuck Berry's "Peppermint Twist."

Mistletoe

Embracing under mistletoe started in ancient Britain, second century B.C. Druids celebrated winter by cutting it off trees with a gold knife and burning it as a sacrifice. They hung it in their homes to ensure a year's good fortune and harmony. Guests embraced under the sprig. It was posted on the house to welcome weary travelers. And it was supposed to help female fertility. With all its pagan associations, the Church forbade mistletoe. In some parts of England, it was banned even into this century. We hope it'll still be considered naughty into the next.

FELIZ POINSETTIA

Everybody has tree-trimming parties. A spicier idea is inspired by that other favorite holiday plant, the poinsettia.

Originally from Mexico, where it's called "flower of the blessed night" because it looks like the Star of Bethlehem, it was imported to this country in 1828 by the U.S. ambassador, a guy by the name of ... Robert Poinsettia. Great excuse to serve frosty margaritas at a holiday cocktail.

The Setup

Fill the house with the plants with the small white flowers and tapering red leaves that are often confused for petals. In South Carolina, Mr. Poinsettia's home state, they create a poinsettia tree with the plants piled in concentric tiers.

The Bar

Frosty margaritas! A bowl of lemons, limes and oranges carved with designs, like a heart or a peace sign.

The Fun

Turn the lights down and the tunes up. Everyone dances to salsified Christmas anthems—holding sparklers. At mid-

night everyone lines up in size order, gets blindfolded and swings at the piñatas.

The Feast

Self-cater this affair from the best Mexican restaurant in your neighborhood. Tamales are the tradition south of the border. Lay them out alongside tacos and other finger food. Remember to put the green guacamole beside the red salsa.

The Dessert

Two plates of cookies: macaroons and Christmas cookies. Guests assemble around the platters and toss a coin—heads wins a cookie, tails a macaroon. Toss 'til the plates are empty. This was a game Frida Kahlo used to play. Then serve one of the Mexican painter's fave holiday desserts, a watermelon, split in quarters with *¡Viva la Vida!* carved into the pink flesh.

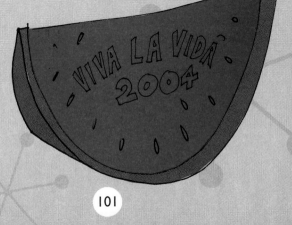

LOTS O' LUCK NEW YEAR'S BASH

On this auspicious night of the year, any and all luck traditions are welcome. They augur well for the New Year and help rev up the revelry.

Invitation

Glue a heads-up penny at the top of a blank card, beneath it jot the where-and-when. Oh, and ask people to bring a baby picture.

The Setup

Cover the ceiling with helium balloons tied with long streamers—a jungle of ribbons. Hang horseshoes over the doors.

The 21 Bar

A champagne cocktail bar, with all variety of mix-ins to keep the basic bubbly from seeming flat. OJ and an orange blossom for mimosas, crème de cassis for kir royales, crushed strawber-

ries for Italian Fragolinis. It's called the 21 Bar, because everyone has to show photo ID, their baby photo, to get served.

The Buffet

Cover the table in confetti. Serve good-luck foods. Fish is lucky in Italy, as is contechino, the giant sausage served with lentils. Since lucky dishes aren't always the prettiest, serve them in cute party portions. Black-eyed peas crostini. A platter of forks holding a single twirl of long noodles (lucky in China). Twelve grapes at midnight in custard tarts.

The Guests

Plenty of noisemakers and party hats—top hats, tiaras, and that lucky four-leaf-clover bowler from St. Patty's Day.

The Fun

All the lucky customs. Wear yellow underwear, throw a bucket of water out the window at midnight. Add some new ones, like a twenty-one-balloon salute—pop, pop, pop, pop . . . at the stroke of midnight!

Sommelier Wrap . . .

That's the cloth around the bottom of the wine bottle that absorbs drips and looks elegant. Fold a napkin in half to make a triangle pointing up, and then fold bottom up one inch. Fold again another inch and a half. Take the top point of the top layer of napkin and fold it down over the bottom fold. Place bottle on back fold. Lift front and back of napkin and tie in back of the bottle, over the back triangle.

LET'S BLOW THIS ICICLE STAND!

Organize some celebrating outside the house. With so many festive festivities already going on this time of the year, you just have to lead the way.

Holiday-Capades

Invite everyone to a skating party. How often do you get to wear really short wool skirts, tights and leg-warmers? Stave off the cold with cocoa in thermoses, and scarves long enough to wrap up a potential hot couple. For a perfect 10, hire an instructor to keep the party from going around in circles and teach the gang some new axels.

Cut Down a Xmas Tree

Anybody got a truck?

Snowball Fight

Designate two captains; each picks a team. Have a bag of red-and-green (or blue-and-white) wool caps ready. Phase 1: Each team has twenty minutes to build a fort. Phase 2: Pass around the mulled wine, and take smiling team photos. Phase 3: Let the snowballs fly 'til somebody cries.

Urban Caroling

Armed with tambourines, triangles and bells, take your band of merry friends around town and see if you can get some contributions. Then give all your earnings to the Salvation Army Santa on the corner.

Drive on Lovers Lane

Take a romantic drive to your nearest suburb with your sweetie to admire all the houses with the most outrageous lights. Or turn it into a high-roller affair, and rent a limo for you and the rest of the yahoos. That way everyone can enjoy some holiday spirits on the ride, and pop out of the moon roof every once in a while for a better look.

Sledding Expedition

Sherpa your party to the top of the hill, loaded with supplies: flasks, goggles, crampons. Pass out brown bags with hand-warmers and snacks to stay alive—brownies to get you high (on sugar, at least).

Shopping Trek

Make it a not-so-secret-Santa party. Hit the stores and get all your girlfriends' shopping done *with* your girlfriends. "You

want that pink eye shadow? I'll buy it for you!" No one goes home 'til everybody's lists are done.

High Tea

Invite Grandma for a new tradition—scones and clotted cream at a nice old hotel in front of the fireplace, dressed up with vintage bags, hats, gloves. She'll talk about it all year.

Mini Pilgrimage

Visit Hartford, Connecticut, where Mark Twain's house is decked for Xmas just as it was in 1874, or Greensboro, North Carolina—O. Henry's birthplace, in time to see the historical society decorate the commemorative "Gift of the Magi" tree with Jim's watch and Stella's comb.

Nature Walks

Night ones are fun and scary. Maybe you'll spot the legendary Three Wise Owls.

HANUKAH

The miracle of Hanukah took place back in 168 B.C.E. (Before the Christian Era, as the Jewish people say), when the Emperor Antiochus, a Syrian Greek, conquered Jerusalem and wanted to turn everyone Greek. Five hunky Jewish brothers (or at least that's how we picture them) named the Maccabees led a revolt and, after three years of fighting, finally, against all odds, achieved *victory*. Once free, they set out to rededicate their temple, a ritual that required burning an oil lamp for eight days. Sadly, they only had enough olive oil for one night. But a miracle happened and the lamp burned on for eight days straight. Thus, the Festival of Lights! This holiday involves lighting a nine-pronged candelabra called a menorah—one candle on the first night and one more every evening at sunset, for eight evenings, and giving the children a gift on *every night!*

Oh, and you have to eat foods that are fried in oil, which used to be a huge luxury when olive oil was dear. Now it's a huge luxury because it's quite fattening. But a religion is a religion, so if you *must* eat doughnuts because it's *required* by your *religion,* then So Be It.

Amen.

STAR-STUDDED HANUKAH PARTY

Sitting around lighting candles and, pardon the expression, porking out on fried food, it's easy to forget that the heart of the Hanukah story is about competition. That's why the Israeli Olympics are called the Maccabean Games. But if the origin of Hanukah is the battle to preserve Jewish identity and the symbol of Jewish identity is the six-pointed star, what better way to celebrate that than by identifying Jewish stars in a few heated rounds of Celebrity?

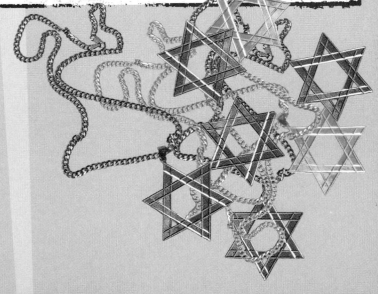

The Setup

Stars everywhere. Dangling from the ceiling. Blinking blue string lights tacked into 6-pointed stars on the window and front door.

The Bar

Olive-branch martinis (page 140) and baby potato latkes (page 139) as crispy as chips. Hang eight-by-tens of famous Jewish athletes (Sandy Koufax, Goldberg!). Coasters you've customized with Two Truths and a Lie, listing three celebs— two Jewish stars and one who's not. Joey Ramone, Eddie Vedder, Gene Simmons. Consider it a warm-up for the Big Game to come.

Serve

Anything your star-shaped cookie cutter can press through. Star-shaped finger sandwiches on rye, salmon canapés. Alongside the traditional tiny jelly doughnuts called suganyot (page 138), star-shaped sugar cookies (page 137), each with a guest's name written on it in Tinseltown silver icing.

The Guests

Wear Star of David necklaces, silver for one team, gold for the other. Which brings us to . . .

The Fun

A game of Jewish Celebrity. Just like regular Celebrity, the crowd divides into two teams. Everyone gets a pen and a stack of twenty small pieces of paper on which he or she writes the names of actors, rock stars, writers, politicians or anyone famous they believe to be Jewish. Fold up all the names and put them into a hat or bowl. Each player gives his team clues to guess as many Jewish stars as she can in one minute. "Famous anchorwoman, talks with a lisp, known for making celebrities cry . . ." "Barbara Walters!" "She's Jewish?" Play until all the names in the hat are gone and people are yelling crazy things like, "Gwyneth Paltrow does so count!"

Below, an abundance of party ideas that may be hokey, but are plenty fun.

Knitting Party

Guests either bring a project, or can learn to knit from the pro you've arranged to give a few lessons. Decorate the tree with wool bows, all connected to a GIANT ball of yarn.

Gift Wrap Session

Everyone brings their gifts and shares wrapping paper and issues. Oops, Freudian slip. Tissues. Serve tea.

Gingerbread House Raising

Build something worthy of *Architectural Digest*, then leave the roof undone and digress into anatomically correct gingerbread men. *"An' I had but one penny in the world, thou should'st have it to buy ginger-bread."*—Shakespeare, *Love's Labours Lost*

Progressive Dinner

Something about your homemade casserole: It looks better at your home. So instead of having the potluck at one person's place, move the caravan from house to house. That way you get to see everyone's decorations and no one's gross-looking Tupperware.

Cookie Exchange

My thimble cookies for your sugar ones. Add a little salt to the party recipe by inviting boys.

December 21 All-Night Party

It's the shortest day of the year. Make it last all night long.

Makin' Merry—Toasts and Games

Chapter 8

The
Moving Feast

You love 'em. You wouldn't trade 'em for anything. You'd do *anything* for them. Still, sometimes spending twelve straight hours with your family can be kind of . . . boring. Not that that's a bad thing! There's something oddly pleasurable about the same-old same-old. Comforting, like watching the PGA seniors tournament with the sound off. That said, it doesn't hurt to conjure Swell hostess powers: Infuse the festivities with adrenaline, whether sentimental or mental stimulation. Consider it a safety precaution. Guests are less likely to fall asleep at the wheel on the way home if they have something more lively to talk about than, "The white meat was *very* moist."

TOASTESS WITH THE MOSTEST

Toastmaking. That enviable ability to stop time and celebrate the moment is a lost art. Everyone wants to rise to the occasion, but what to say? People get flummoxed when they think they have to be witty or poetic or sum up something meaningful in one pithy phrase. With good reason. *It's too hard.* Take the pressure off. A toast does not have to be a speech. But it also needn't be a cursory "Health and happiness—hear, hear!" Just offer a few relaxed words of appreciation. Avoid generalities that drift into mushy cliché. And be specific. A well-done toast can be as plain, crisp and warm as, well, toast. It also helps if you have a line to start. . . .

I'd just like to say . . .
. . . thanks that we're all here at one table. . . .

Name a few people who braved snow or traffic to make the trip. Acknowledge new faces (". . . that Debi found a guy who has such great taste, not only in women, but in champagne!" Clink, clink.) Don't forget to remember a few who couldn't make it this year. Take a second to toast absent friends by name. And mention what you'll miss.

. . . how lucky we are. . . .

It's been a year since you've all been together. Seems like a good time to just note a few of the things that happened since you were last assembled. Count a few blessings: That Little Kit got to play Cinderella. That David finished building his robot. Kevin is striking out on his own. Not everything has to be news. Say how lucky you are that Aunt Agnes has once again made her gooseberry tarts.

. . . I'd like to make a few wishes for the year ahead. . .

That Todd and Michael get their dream house. That Grandpa gets back on the tennis court. Everyone could pitch in and share one thing they wish for, out loud, or written down. Make it a tradition; then next year you could start your toast reading last year's wishes, and see which ones came true.

OPW: OTHER PEOPLE'S WORDS

When trying to come up with something pithy and sage and thought provoking, one way to go is to "find" a quote. Attribute it or not. As we say: Good writers copy. Geniuses steal.

"We shall find peace. We shall hear the angels. We shall see the sky sparkling with diamonds." —Anton Chekhov

"We tire of those pleasures we take, but never of those we give." —Not Sure

"May you live all of the days of your life." —Jonathan Swift

"May all your troubles in the coming year be as short as your New Year's resolutions." —Not Sure

"God bless us, every one." —Tiny Tim

READ A CLASSIC

A VISIT FROM SAINT NICHOLAS

How merry to gather 'round the fire and read portions from that favorite holiday classic, *A Compendious Lexicon of the Hebrew Language*. Don't know that one? Perhaps you are more familiar with the other work of that former professor at the General Theological Seminary in New York City, Clement Clark Moore: "'Twas the Night Before Christmas."

Before diving into the fabled poem, warm up the crowd with a quick tale of the making of "'Twas." Moore originally wrote the poem for his own children, and refused to have it published because he thought a work with lines like, "His eyes—how they twinkled! His dimples how merry!" wouldn't be great for his image as a serious academic.

"'Twas" only leaked out to the world when a sneaky relative sent the poem anonymously to an out-of-town paper, where it was published and became an immediate smash success. The poem, which pretty much introduced the whole concept of Santa Claus as a jolly, white-bearded man with a sleigh and reindeer, grew in popularity for fifteen years before Moore finally acknowledged he was the author of this "mere trifle," as he put it. Funny how things turn out: The classics prof started out writing a trifle, and ended up creating a classic of his own.

CAN WE TALK?

CONVERSATION STARTERS

No seating chart is ever perfect. When you hear your great-uncle announcing, "When the GI bill was passed . . ." —again, you know it's time. Gotta spark things up. Find some topic of conversation that will galvanize the table,

incite riotous stories, legendary family tales you never knew. No need for a preamble. Just crank up the volume a notch, and say, "So here's a question for the group. . . ."

"What was the one holiday gift you always wanted but never got?"

"What's your favorite Christmas movie?"

"Have you ever dated anyone as fat as Santa Claus?"

"What was the most charitable thing you ever did in your life?"

"What movie star would you like to get under the mistletoe?"

"Did you ever go to midnight mass/temple high?"

A HOLIDAY SPECTACULAR

IMAGINE THERE WAS NO TELEVISION . . .

When the gang starts to sink into a collective trytophan holidaze, come up with some action to wake up the troops. Stoke the party embers by moving the guests to the living room, where you serve up coffee, chocolates, after-dinner drinks, even some . . . dinner theater.

Pageant

Adapt a classic holiday tale to a theme relating to your family and friends. Our friend Ellen does one every year for her holiday party. One year it was a remake of A Christmas Carol, about

a spoiled, shopping-obsessed girl who is visited by three ghosts—and ends up engaged! Cast your pageant with friends and relatives with a dramatic bent (you'd be surprised how many there are) who can read lines from a script. Or just organize a short skit, *SNL*-style. Ilene and her hubbie Rick once did a good bit about Mary and Joseph's search for a place to stay in Bethlehem, imagining how mad Mary must have been having to travel while nine months pregnant on a donkey, and then learning Joseph hadn't called ahead for a reservation.

Cabaret

Invite guests to bring a talent to the party. Your friendly neighbor reveals a hidden knack for sock puppetry. One couple shows off their newly acquired skill for floating up into simultaneous headstands. Someone does a bad comedy routine, performing a medley of commercial jingles.

Concert

Instruments aren't necessary. Enlist a few friends to rewrite the lyrics to a popular holiday song. Like at "sing night" at camp, make them funny with lots of in-jokes. The more familiar the tune the better: Madonna's "Holiday"; Kool & the Gang's "Celebration"; or an old choir favorite, "It's a Marshmallow World in the Winter."

GAMES GUESTS PLAY

We're not stupid. We know that at this time of year when most Americans start talking about "the game," they don't mean charades or a backgammon tournament. And yet, there's still something to be said for a holiday game you don't watch on TV but actually get to play!

ORANGE YOU GLAD

A good one for parties where guests need to get better acquainted quickly. Divide into two teams and ask each guest to stand in line in boy-girl order. The captain of each team gets an orange and holds it under the chin. (Jaffa oranges make this a particularly good Hanukah game.) On the word *go*, or a cap-gun blast, guests try to pass the orange to the next teammate in line, chin to chin. As soon as someone drops the orange or commits illegal hand usage, the orange goes to the beginning of the line again. Continues until the last person in line successfully passes the orange back to the team's captain.

YOU'RE THE TOPS

Wagering games were invented as a way to pass the time after the Hanukah candles are lit while waiting for dinner to be fried up. Card games that involve betting chocolate

coins, such as Hungarian blackjack, were popular during the Victorian era. But the best-known game involves a four-sided top called a dreidel, patterned after an old German game. On the four sides of the dreidel are four Hebrew letters: *nun*, *gimmel*, *heh*, and *shin*, that all together spell out the phrase "A great miracle happened there." Here's how it works: Each player is given a stack of chocolate coins. Then everyone antes up, and the first player takes a turn spinning the top. If it falls to reveal *nun*, the spinner gets *nisht*, or nothing. The pot remains intact, everyone antes up again, and the next player spins. If the dreidel lands on *gimmel*, the spinner gets *gantz*, which means "all"—the whole pot. Heh receives *halb* or half, leaving the remainder for the next round. Finally, if a spinner gets *shin*, she has to add chocolates from her own pile to the pot. The game is over when one player wins everything, or the latkes are ready.

SCAVENGER HUNT

Divide into two or three teams and give each team a list containing twenty objects they have to find, and a box to put them in. Each list should be totally different. Then give everyone a half hour to find as many articles as they can. Could be a movie stub, a book by Charles Dickens, some punch, a used stamp, a photograph, an angel. Of course, the game is all the more fun if the list is full of clues, leaving more room for interpretation. "Something soothing for the head"—a pillow or a Xanax?

MIRACLE WORKERS—DECK THE HALLS

Customize a deck of "magic holiday cards" to perform tricks that will amaze and stupefy the family and friends.

Start with this one. The balancing glass. Hold a magic holiday card in your right hand and place a nonbreakable tumbler on the top edge of the card. Watch it fall off. Promise the audience that you will perform a bit of magic and balance the tumbler on top of the card. Show the audience the card, both sides. What they don't know is that, in fact, you are holding two cards. One folded lengthwise and half pasted to the back of the other to create a flap. Keep the flap closed while making your unsuccessful attempt to balance the glass. On the second try, use a free finger to open

the flap. The tumbler will easily balance on the three edges. Show the audience only the front of the card, and watch their mystified faces!

THE PAPER BAG GAME

In small towns all over Illinois, or maybe just at the Rowley house in Barrington, they play a game that seems almost limbo-inspired, only with the limited supplies of a paper bag and scissors. Everyone gathers 'round a paper bag and the object is to pick it up with your teeth, and not using your hands. After each round the paper bag is cut shorter, until it involves people shimmying on the ground and flopping about like flounder to pick up the bag.

Or you could just turn on the game.

BUBBLE BLOWING TOURNAMENT

A half-time diversion. Cover the dining table with a tablecloth, set up a pair of chopsticks or candles on either end as goal posts. Two players try to blow suds through the other team's end zone first.

BEDTIME STORY

Designate a big chair by the fire, or the yule log burning on TV, where the guest with the most radio-quality voice puts on her sexy librarian glasses, and reads aloud. The rest of the gang flops on the couch, grabs pillows on the floor, and snuggles down to listen to . . .

"A Child's Christmas in Wales" by Dylan Thomas

"The Gift of the Magi" by O. Henry

A Christmas Carol by Charles Dickens

"A Christmas Memory" by Truman Capote

An Angel for Solomon Singer by Cynthia Rylant

Christmas Day in the Morning by Pearl S. Buck

The Little Match Girl by Hans Christian Andersen

OR THESE SNOW-MELTERS

A Christmas Seduction by Amanda Browning and

Daddy's Angel by Annette Broadrick

Holiday Tales of Sholem Aleichem, by Sholem Aleichem

The Power of Light: Eight Stories for Hannukah
by Isaac Bashevis Singer

"The Angel Levine" by Bernard Malamud

It's a Wrap

Every Day's
a Holiday

—MAE WEST

January—the holiday hangover. All that's left is a Hefty bale of crumpled wrap, a snowboarding hat with bells (and no receipt) and a pile of half-broken resolutions. Even the radiator's whistling the blues. Rather than contemplating treadmill slavery to work off all that green lasagna, you'll feel better if you resolve to keep the party going!

Dial up some pallies for some bloodies and Tylenol, and call it a Hangover Brunch. Don't stop there. Hang mistletoe in February. Recycle the Hanukah stars for an Oscar gala in March. The ideas in this book should get your celebration engine revved year round. Find any excuse-occasion to whip out the punch bowl.

Pull Secret Santa out of hibernation on Valentine's Day for an office mate with no V. Plant a Twelfth Night surprise inside an April Fool's cake. And definitely leave those Happy Lights on the wall. At least until your birthday.

Holiday Recipes

Get Stiff Egg Nog
40 servings

1 dozen eggs, separated
1 cup granulated sugar
1 cup bourbon whiskey
1 cup cognac

½ teaspoon salt
3 pints heavy cream
Grated nutmeg

With an electric mixer, beat the egg yolks with the sugar until thick and lemon-colored. Slowly add the booze to "cook" the eggs, while beating at a slow speed. Add the salt to the egg whites and beat until almost stiff. Then whip the cream until it's stiff, too. Fold the yolk mixture into the cream. Add the egg whites. Chill one hour. Sprinkle with nutmeg and serve 'til the guests get stiff.

Note: Add skim milk to thin it out and make it diet!

Mean Grinch Punch

WHICH THE GRINCH STOLE FROM AUNT BONNIE

In a big ol' punch bowl mix together ...

1 liter of ginger ale

2 bottles of pink champagne

1 quart of mai-tai mix

1 cup brandy

Ice cubes or a frozen ring of ice with pieces of fruit or whatever goes with the holiday theme.

Aunt Bonnie's Non-alchy Punch

In a large punch bowl mix together ...

2 quarts of raspberry sherbert

1 liter of raspberry 7-Up

Uncle Don's Mincemeat Tarts

The key to mincemeat pie is flaky crust, cognac dropped on top, and tiny portions.

Bottle of the best mincemeat available *(no one really wants to ask a butcher for any mystery meat called suet)*

Two apples, finely chopped

2 cups seedless raisins

1 cup cognac

Flaky pastry dough *(recipe follows)*

Mix mincemeat and fruit together and fill pastry-lined tart tins. Add to each tartlet a dot of butter and a splash of co-

gnac dispensed with great fanfare and an eyedropper.
Bake at 400°F for 15 minutes.

Pastry Dough

2½ cups of flour

1½ teaspoons salt

¾ cup butter or other shortening

3 or 4 tablespoons water
(the less water the better)

Make a hollow in the center of the flour and salt, add bits of shortening and mix with fingers, then add water and mush into a ball. Wrap in wax paper to chill for a half hour. Then roll! To $1/8$- inch thick. Use a biscuit cutter, the top of a jar, or something round that seems like the right size to cut the dough to fit into the bottom of the tart tins.

Cynthia's Dad's Favorite Spritz Cookies

Makes 4 dozen cookies

1½ cups butter

1½ cup sugar

1 well-beaten egg

2 teaspoons vanilla

4 cups flour

1 teaspoon baking powder

Colored sugars, for decorating

Cream together the butter and sugar. Add the egg and vanilla and beat well. Sift together the dry ingredients (except the colored sugars). Add to the creamed mixture. Mix to a smooth dough. Force through a cookie press. (Little wreaths, or any other shape). Decorate with colored sugars. Bake on

an ungreased cookie sheet in a 400°F oven for 8 to 10 minutes.

Powdered sugar icing:
 1 cup sifted powdered sugar
 ½ teaspoon vanilla
 Milk

Mix together sugar and vanilla and enough milk for "painting" consistency. Mix as many batches as you need. Add food coloring to create a whole palette.

Star-Shaped Sugar Cookies
Makes 3 to 4 dozen cookies

2¼ cups flour
¼ teaspoon salt
¾ cup sugar
12 tablespoons butter

1 egg
1 tablespoon lemon zest
1 teaspoon vanilla

Sift together flour and salt. Cream sugar and butter, then add the egg, vanilla and lemon zest. Add dry ingredients, beating til well combined. Scrape dough into plastic wrap. Pound into a big, flat, round disc. Refrigerate for two hours. Roll on a lightly floured surface to ⅛-inch thickness. Cut into six-pointed stars for Hanukah or five-pointed North stars. Place on an ungreased cookie sheet. Bake at 350 degrees for 8 to 10 minutes or til done.

Bourbon Balls

Makes about 6 dozen cookies

A SWELL GIRL CAN "BAKE" COOKIES WITHOUT EVEN TURNING ON THE OVEN

This recipe could be made a couple of weeks ahead, so the cookies can ferment.

1 cup pecans, chopped fine
1 cup vanilla wafer crumbs
2 tablespoons dutch cocoa
1 cup powdered sugar

1$\frac{1}{2}$ tablespoons light corn syrup
$\frac{1}{4}$ cup bourbon, or more!

Mix all ingredients together. Form into small balls using one rounded teaspoonful of the mixture for each ball. Dust in powdered sugar and cocoa, and ferment, er, store in a tightly covered container. Ginger snaps or crushed chocolate wafers do the trick, too, if that's your poison.

Suganiyot—Hanukah Doughnuts

Makes about 20

2$\frac{1}{2}$ cups flour
2 cups hot milk
1 package dry yeast
$\frac{1}{4}$ cup lukewarm milk
6 egg yolks
$\frac{2}{3}$ cup sugar, plus more for dusting
1 teaspoon vanilla

1 teaspoon grated lemon zest
1 teaspoon grated orange zest
$\frac{1}{2}$ cup butter
your favorite jam for filling
oil for frying

Sift 1 cup of flour into the hot milk and beat until smooth, then allow it to cool. Dissolve yeast in the lukewarm milk, add to the flour and milk mixture. Mix the egg yolks and sugar with the vanilla and zest and add it to the dough. Add the remaining flour and the butter and knead. Cover with plastic wrap and allow it to rise (about 45 minutes). Roll out the dough on a floured board to about $\frac{1}{2}$-inch thick and cut into rounds. Put a teaspoon of jam in the center of one round and cover it with another round. Press the edges together and allow to rise again in a warm place.

Meanwhile, in a deep pan or fryer, heat the oil to 375 degrees; a drop of water will crackle in it. Fry the donuts in hot oil til golden. Remove from oil and drain on paper towels. Dip the donuts in sugar and arrange, sugared side up on a platter. Serve coffee, call the cops.

Joy's Latkes

4 potatoes
1 chopped onion
1 teaspoon salt
$\frac{1}{4}$ teaspoon pepper
1 egg

3 tablespoons flour or
Matzoh meal
$\frac{1}{2}$ tablespoon baking powder
$\frac{1}{2}$ cup oil for frying

In an electric blender, mix the potatoes, onion, salt, pepper, beaten egg, matzoh meal and baking powder until very smooth. Heat the oil in a skillet. Drop the potato mixture in by the tablespoonful. Fry until browned on both sides. Drain well. Make little tinies for hors d'oeuvres and bigger, thicker

COCKTAILS

XOXO

To whet lips for the mistletoe, mix 1 ounce vodka, 2 ounces apple pucker and a Red Delicious slice for garnish. Hardcore apple lovers can go the extra level of infusing the vodka in the Red Delicious a week before, to get the liquor in the mood.

Hot Pink Gin Punch

Shake 3 ounces gin and 2 dashes of angostura bitters with cracked ice. Strain into a cocktail glass and garnish with a squeeze of lime. Whoa: 3 ounces of gin? Add tonic and more lime juice for drinkers who aren't quite ready for that much holiday spirit.

Olive-Branch Martinis

Medium dry. Shake, or stir together 2 ounces gin to 1 ounce dry vermouth. Drop in a dash of olive juice from the jar. Put as many olives as you can on a toothpick—your "branch"— and offer to anyone you'd like to kiss and make up with.

ones for dinner, served with meat dishes or with apple sauce.

The only thing you can do to ruin these babies is to use the grater attachment on the Cuisinart. Then they come out stringy like Swiss rösti. Remember, the first batch is always the worst.

Rick's Apple Sauce
WHY BUY IT? MAKE IT!

Apples!

Peel a few apples, trying for that perfect spiral, core them with one of those Ron Popeil thingies that cuts them into six sections and throw them into a saucepan with a tiny bit of water or apple juice, to reinforce the flavor. They'll get mushy on their own, but use a potato masher if you're in a hurry. Add sugar or cinnamon, and you'll never have to wrestle down another impossible jar lid again.

The Unknown Turkey
ROAST TURKEY IN A PAPER BAG

Stuff and truss a 12- to 15-pound turkey. Place 1 pound butter into small pieces, in the bottom of a brown paper bag. Make sure the seam side of the bag is on the top where you do the buttering. Rub the outside of the turkey thoroughly with remaining butter. Seal the bag by stapling it closed, so no air can

get out. Place the bagged turkey on a high rack, in a roasting pan containing an inch and a half of water. Roast for 3 to 3½ hours at 325 degrees. When done, slit the bottom of the bag so the juices drain into the roasting pan. If not done, keep cooking. Once done, let the turkey rest for a half hour before carving.

Chestnut stuffing

2 cups chestnuts	1 pound day-old bread,
1 cup butter	cubed
½ cup chopped onion	3 eggs
1 teaspoon salt	¼ cup milk
¼ teaspoon pepper	

Preheat oven to 350 degrees. Make a small slit in the top of each chestnut and boil for 25 minutes. Peel the shells and chop. Melt butter in a medium saucepan, stir in the chestnuts, onion, salt and pepper. Cook until the onions are tender. Transfer to a medium baking dish, and mix with the cubed bread.

In a small bowl, beat the eggs and milk together. Pour it over the bread mixture. Bake for 30 and 45 minutes until surface is crisp and lightly browned.

Cynthia's Southern Caviar Crostini

That's lucky black-eyed peas for all you Yankees

1 bag black-eyed peas
1 medium onion, chopped
1 green pepper, chopped
4 tablespoons balsamic vinegar

2 tablespoons lemon juice
salt and pepper
1 baguette
olive oil, enough for brushing

Cook a package of black-eyed peas. In a bowl mix chopped onions, chopped green peppers, balsamic vinegar, lemon juice. Let the mixture sit in the fridge overnight. When ready to serve, slice a baguette in $\frac{1}{2}$-inch slices, brush with olive oil, place on baking sheet and broil til brown. Top with black-eyed pea mixture.

Lucky Fish

¾ cup olive oil
¼ cup white wine
¼ cup Nicoise olives
3 potatoes

6 filets sea bass (or favorite white fish)
1 rosemary twig

Preheat oven to 400. In bottom of roasting pan mix olives, oil, wine, and potatoes, sliced as thin as chips. Roast potatoes for about 15 minutes or until starting to brown, turning once. Meanwhile, salt and pepper the fish. When potatoes are golden lay the filets on top, drizzle with pan juices, add a sprig of rosemary. Roast another fifteen minutes. Decant onto a serving dish!

Aunt Julie's Fruitcake
THE BEST OF ALL THE ROWLEY FRUITCAKES

1 pound butter

2 cups sugar

½ teaspoon salt

12 eggs

Grated rind of ½ lemon

Grated rind of ½ orange

Juice from lemon and orange

4 ounces dark rum

2 cups flour

2 teaspoons baking powder

2 additional cups flour mixed with fruit

½ pound candied red cherries, cut in quarters

½ pound candied green cherries, cut in quarters

½ pound citron chopped

2 pounds white seedless raisins

⅓ pound candied green pineapple, chopped

1 pound butter

2 cups sugar

½ teaspoon salt

12 eggs

Grated rind of ½ lemon

Grated rind of ½ orange

Juice from lemon and orange

4 ounces dark rum

2 cups flour

2 teaspoons baking powder

(⅓ pound candied red pineapple, chopped

⅓ pound candied yellow pineapple, chopped

¼ pound candied lemon peel, chopped

¼ pound candied orange peel, chopped

½ pound raw brazil nuts, chopped

½ pound blanched almonds, chopped

½ pound raw pecans, chopped

Day One

Grease three 5x9-inch loaf pans, line with heavy brown paper, which has also been greased. I use regular Crisco. Set these aside for later.

Pick over and clean raisins. Cover with lukewarm water

and let soak overnight. Next day drain and lay out on a couple of dish towels. Wash all candied fruit, lay on dish towel overnight and chop the next day.

Chop nuts and put aside. Using a large mixing bowl mix raisins, candied fruit and nuts with 2 cups of flour. Be sure all fruit is covered with flour. You will need to use your hands.

Day Two

In a mixer, I use a Kitchen Aid, cream 1 pound butter, add 2 cups sugar, slowly. Add ½ teaspoon salt. Add 12 large eggs, one at a time, cream well. Add 2 cups flour mixed with 2 teaspoons baking powder, add lemon and orange rind, juice from lemon and orange and the dark rum. Mix well. Stop mixer and remove beater. At this time pour this mixture over the flour, fruit and nuts mixture. Mix well, until everything is combined. Fill each of the three loaf pans with the mixture evenly.

Place in a preheated oven at 250 degrees. You will need two racks in the oven. The bottom rack will have a 13x9-inch pan filled halfway with water. On the top rack place the three loaf pans.

Cook for 2 1/2 to 3 hours. Remove pans from oven and let cool 1/2 hour and remove fruitcake from pan.

Place on a cooling rack and cool overnight.

Day Three

Put two tablespoons dark rum on each of the loaves of fruitcake, wrap each load in heavy duty aluminum foil, snuggly. Store in an air-tight container; place in an apple or an orange. Repeat the rum bath every week for four weeks, then every month. I usually make this Labor Day weekend and use during the Christmas season.

Any questions call Uncle Buzz, 406-683-4836.

Sources

Cocktail: The Drinks Bible for the 21st Century, Paul Harrington
and Laura Moorhead, Viking (New York, 1998)

The Complete American Jewish Cookbook, Anne London,
The World Publishing Company (Cleveland, 1952)

The Extraordinary Origin of Everyday Things, Charles Panati,
Harper and Row (New York, 1987)

Frida's Fiestas, Guadalupe Rivera and Marie Pierre Coule,
Clarkson Potter (New York, 1994)

High Spirits, H. Paul Jeffers, Lyons & Burford, Publishers
(New York, 1997)

Holidays and Celebrations, Allen D. Bragdon, Watson-Guptill
Publications, (New York, 1994)

How the Grinch Stole Christmas, Dr. Seuss, Random House
(New York, 1957)

Mrs. Beeton's Christmas Book, Pamela Westland, Ward Lock,
Villiers House (London, 1990)

Nutcracker, ETA Hoffman, translated by Andrea Clark Madden,
Ariel Books/Alfred A. Knopf (New York, 1987)

An Old-Fashioned Christmas, Karen Cure, Harry Abrams
(New York, 1984)

Southern Christmas, Emyl Jenkins, Crown Publishers, Inc.
(New York, 1992)

The Twelve Days of Christmas Cookbook, Suzanne Huntley,
Atheneum (New York, 1965)

Victorian Christmas Crafts, Barbara Bruno, Van Nostrand Reinhold
Copmany, Inc. (New York, 1984)

Vintage Cocktails, Susan Waggoner and Robert Markel,
Smithmark Publishers (New York, 1999)

A Woman's Christmas, Arlene Hamilton Stewart, Hearst Books
(New York, 1995)

The World of Jewish Entertaining, Gil Marks, Simon and Schuster
(New York, 1998)